Tattoo Art Around the World

Diane Bailey

ROSEN
PUBLISHING®

New York

Published in 2012 by The Rosen Publishing Group, Inc.
29 East 21st Street, New York, NY 10010

Library of Congress Cataloging-in-Publication Data

Bailey, Diane, 1966–
Tattoo art around the world / Diane Bailey.—1st ed.
 p. cm.—(Tattooing)
Includes bibliographical references and index.
ISBN 978-1-4488-4618-4 (library binding)
ISBN 978-1-4488-4622-1 (pbk.)
ISBN 978-1-4488-4743-3 (6-pack)
1. Tattooing. I. Title.
GT2345.B35 2012
391.6'5—dc22

2010048428

Manufactured in the United States of America

CPSIA Compliance Information: Batch #S11YA: For further information, contact Rosen Publishing, New York, New York, at 1-800-237-9932.

On the cover: Top: Many people see tattooing as an art form displayed
on their bodies, so the more tattoos they have, the more art-like they
become. Bottom: A man having his back tattooed by a Sak Yant master
in Singapore.

Contents

INTRODUCTION

No postcards. No T-shirts. No coffee mugs. When British Lieutenant James Cook returned from his trip to the South Pacific in 1771, he didn't bring boring souvenirs home to his family and friends. Instead, he and his crew brought something few people in Britain (or the rest of Europe) had ever seen before: a tattoo.

Cook and his crew had been exploring Tahiti and other islands. While there, they were struck by a practice the Tahitians called *tatau*. The word meant "to mark." The islanders were tattooed all over their bodies. Cook and his crew didn't know what to make of this strange practice. Joseph Banks was a naturalist on the expedition. He wrote, "What can be sufficient inducement to suffer so much pain is difficult to say; not one Indian (though I have asked hundreds) would ever give me the least reason for it; possibly superstition may have something to do with it. Nothing else in my opinion could be a sufficient cause for so apparently absurd a custom."

Maybe the men in Cook's crew were a superstitious bunch. After seeing the islanders' tattoos, the sailors wanted them, too. They learned the techniques of tattooing from the natives. Tools made of bone and shell were carved with "teeth" that were dipped into an oily soot. Then, this comblike instrument was hammered into the skin to transfer the dye.

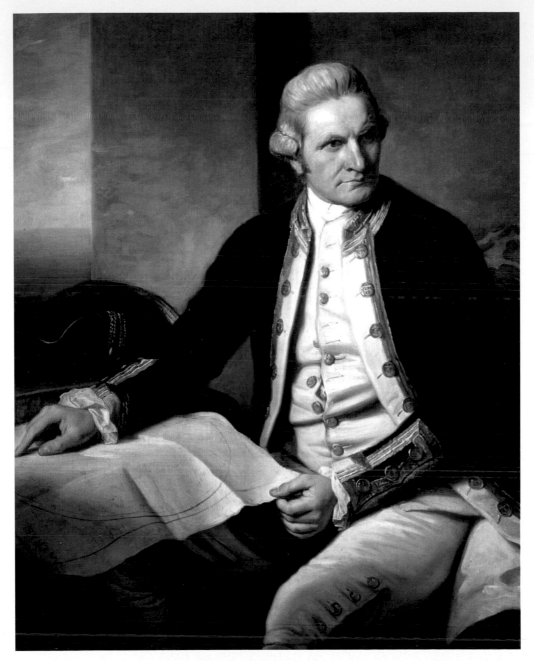

After traveling to the South Pacific, eighteenth-century explorer James Cook and his sailors learned the art of tattooing and brought it back to Europe, where it soared in popularity.

The boat ride from Tahiti back to England was long. Although they visited the islands in 1769, it was two years before the English sailors landed on their home shore. This gave them plenty of time to practice their new tattooing skills on each other.

The idea of tattooing wasn't brand-new to Europe. However, it had been centuries since it was popular. Although ancient civilizations had used tattoos, the spread of Christianity stamped it out. Christians felt that it was sacrilege (speaking or acting against God) to mark the body. As a result, tattooing was mostly used as a way to identify outcasts and punish criminals. By the time Cook returned, however, it seemed England—and the rest of the continent— was ready to give tattooing another try. Tattoo shops sprang up in port cities, offering a little taste of the exotic to those who were brave enough to try.

The sailors on Cook's voyage brought the art of Polynesian tattoos to modern civilization. However, tattoo art had been flourishing in other parts of the world. The tribal cultures of Polynesia and the Americas had their own styles of tattooing. So did the Japanese. Over the next couple of centuries, these styles would start to blend and influence each other. New styles of tattoos would develop. New attitudes about them would emerge as it became clear that tattoos were more than skin deep. Getting a tattoo wasn't just an impulsive move. It was a form of art and an expression of culture.

An Ancient Practice

Did prehistoric humans have fashion trends? Were capri pants in one year and out the next? We'll never know, but what we do know is this: ancient people did have tattoos. And if those went out of style, too bad. That's the thing about a tattoo—it's permanent. There's no going back.

Archaeologists have discovered mummies and ancient art that prove people have been getting tattoos for thousands of years. The earliest tattoos were just simple dots and lines. The earliest equipment was just pieces of bone and dyes that were made from plants. The "tattoo parlor" might have been a cave with some good firelight and two people: the artist and the "canvas."

Prehistory

In 1991, hikers in the Alps made an incredible find. On the border of Italy and Austria, under a few layers of snow and ice, they found the

preserved corpse of a man. When archaeologists studied the man, they determined he was old—more than five thousand years old! Instead of his body having rotted away, leaving only the bones, this man was remarkably intact. He had been preserved by the freezing temperatures. He was named Ötzi, after the Ötztal Alps where he was discovered.

Because his skin had not decayed, scientists found many tattoos on Ötzi's body—more than fifty altogether. Small dots and lines had been placed on his lower spine, behind his knee, and on his ankle. Researchers pointed out that these areas corresponded to acupuncture points. Acupuncture is a traditional type of Chinese medicine. Needles are inserted into the skin at certain places to help relieve pain or other ailments. Scientists believed Ötzi's tattoos might have been for the same reason. Also, his tattoos would normally have been covered up by his clothes, so they probably weren't meant to be decorative.

Tattooed mummies from about 2,400 years ago have also been found in Siberia, a remote part of Russia. These mummies were part of a tribe of people called the Pazyryks. One of the bodies was covered in elaborate animal tattoos, including a donkey, a fish, rams, and deer. This mummy was probably the body of the tribe's chief. The tattoos were a way to show how important he was within the tribe. There were other pictures of mythical animals like griffins. Scientists think that the Pazyryks believed these fantastical creatures had magical properties that would protect or strengthen the person who wore them. Like Ötzi, the chief also had several

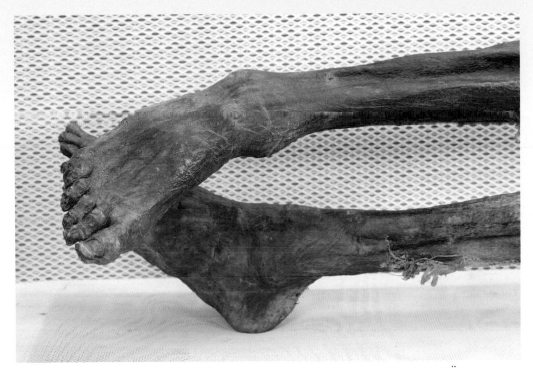

Scientists found more than fifty tattoos on the preserved body of Ötzi, a prehistoric man who lived more than five thousand years ago. Their presence shows that tattooing has been practiced for centuries.

small circles tattooed along his spine and on his ankle, probably to help with sickness or injuries.

The Picts were a people who lived from about 7000 BCE to 850 CE in the area that is now Scotland. The Romans described them with the Latin word *Pictii*, which means "the painted ones." According to reports, they had pictures of birds, fish, and other animals tattooed all over their bodies. The Picts used iron needles to prick the skin.

Although these are the earliest people found with tattoos, archaeologists have found tattoo needles and pigments that date

from the Upper Paleolithic period (38,000 BCE to 10,000 BCE). Tattooing may have been going on for longer than we know.

Egypt, Rome, and Greece

In ancient Egypt, it seems that only women got tattoos. Mummies from four thousand years ago show women with elaborate patterns of dots and dashes. The tattoos were probably related to fertility. They were believed to help a woman be more likely to have children.

Ancient Greeks and Romans also used tattoos. The Greeks adopted the practice from the Persians, who were their neighbors. In turn, the Greeks passed it on to the Romans. Some of the most famous wars ever happened among these cultures. The Greeks and the Persians fought for fifty years during the Greco-Persian Wars. The Roman Empire was extremely powerful and frequently engaged in military action to make it even more powerful. Soldiers were sometimes tattooed so that if they tried to desert—leave the army without permission—they could easily be caught.

Ancient tribal cultures considered tattoos to be status symbols. The Greeks and the Romans, on the other hand, used tattoos to punish people. A tattoo was a way to, quite literally, make a "black mark" against somebody's character. The Latin word for tattoo was *stigma*. Today, that word refers to something that is shameful and will hurt a person's reputation.

In ancient Rome, tattooing was considered abhorrent. The powerful but cruel emperor Caligula sometimes forced his subjects to get tattoos—even though it would make them outcasts.

Plato was an influential Greek thinker. He believed that people who were guilty of sacrilege should be tattooed and banned from society. Plato was just reflecting the attitudes of his time, however. He was generally considered to be a reasonable, intelligent man. Not so the Roman emperor Caligula. By all accounts, Caligula was strange. He was also cruel. He knew tattoos would damage a person's reputation, so he had members of his court tattooed.

Designs and Methods

With the exception of a few mummies found in snowdrifts or Egyptian tombs, there aren't that many surviving bodies from thousands of years ago. Most information about tattoos comes from sources other than actual skin. There are a few written records telling about tattoo practices. Most evidence, however, comes from art. Paintings and statues that have survived through the years show people with tattoos on their bodies.

Although the earliest tattoos used dots and dashes that were easy to draw, these could be combined to form elaborate patterns and designs for a striking look. Abstract, geometric patterns might cover large portions of the body.

Prehistoric people often used charcoal, or soot, as a pigment for tattoos. Ötzi's tattoos included a little bit of quartz, which made them glitter. Scientists aren't sure whether this was added on purpose for a glitzy effect, or whether it just got in by accident.

Connect the Dots

The earliest tattoo designs were abstract patterns, but these eventually turned into pictures. The first evidence of a pictorial tattoo came in the form of the ancient Egyptian god Bes. Bes was a household god. He was there when babies were born. He protected objects that came into contact with people, such as chairs or dishes. He was also in charge of fun; music, dancing, and general partying all came under Bes's command. Images of Bes have been found tattooed on female Nubian mummies from about 400 BCE and can be seen on the thighs of musicians and dancers in paintings from ancient Egypt.

In ancient Rome, a doctor recorded a recipe for tattoo ink. It included the wood and bark of an acacia tree, as well as corroded bronze mixed with vinegar, gall (bile from an animal), and vitriol (sulfuric acid). The ingredients were combined into a powder, and then soaked in water and juice from a leek (which is like a large green onion). The Celts used a plant called woad. The dye that came out of this plant made indigo, which was a deep blue color.

In the Americas, native tribes pricked the skin, and then sometimes rubbed color into the cuts. The Inuit people of the Arctic regions actually "sewed" on tattoos: they coated a thread with pigment, threaded it through a needle, and then used the needle to puncture the skin and pull the thread

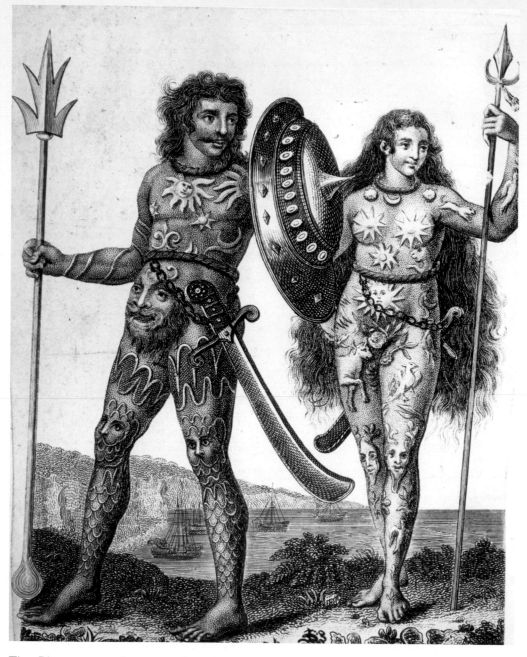

The Picts, an ancient people who lived in present-day Scotland, got their name from a Roman word meaning "painted ones." They were believed to have elaborate tattoos all over their bodies.

through. In Polynesia, a small, sharp comb was dipped into pigment, and then placed on the skin and "tapped" (rather violently) to transfer the pigment into the skin.

Historically, tattoos were assigned mystical powers. They protected the wearer from dangerous spirits and improved his position with the gods. Being tattooed showed a person's importance in a tribe. The specific designs or pictures indicated what his skills were, who his family was, and what kind of person he was. It was believed that a person could channel the spirit of his tattoo. For example, a picture of a tiger could make someone fierce. An eagle gave strength and spiritual power, while a hawk showed self-discipline. A dog, which was traditionally man's best friend, represented loyalty. As tattoos evolved from abstract designs into pictures, animals became the most popular category, and they remain so today.

Centuries ago, people had much less contact with others outside their own culture. Customs, traditions, and art developed independently of each other. Tribal cultures in the Polynesian Islands, Africa, and the Americas all had tattoos—but they each had their own style.

Tribal Tattoos

Getting a tattoo hurts. It made Joseph Banks, the naturalist on Cook's exploration of the Polynesian Islands, wonder why people would bother with them. His guess was "superstition." This term did not give much credit to the beliefs of native people. They probably would have given reasons related to religion or their communities.

Religion and Society

In tribal cultures, people's parents did not warn them against getting a tattoo. It would not hurt their chances of getting a job. On the contrary, in many tribes, the more tattoos someone had (especially men), the more important he was. The most powerful and influential men were those who had proved their worth. This might have been by showing skill in hunting or by fighting enemies. These actions were recognized—and rewarded—by receiving a tattoo. Getting a tattoo was a big

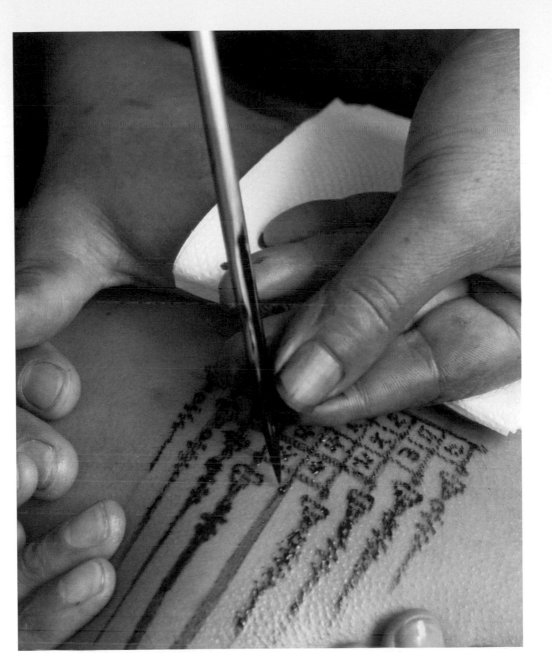

Monks at Buddhist temples in Thailand use long needles to give tattoos. People often choose religious designs that they believe will give them certain powers or protections.

deal. The pain that the wearer endured, the tattoo's perma-
nence on his body, and the fact that he gave up his life force
(blood) to get it, all showed that he was serious.

Tattoos were also believed to have magical powers.
People in many cultures got tattoos as protection against evil
spirits or sickness. Others used them to show their devotion
to the gods or help them pass into the afterlife. Both girls
and boys were tattooed to show their readiness to be adults
in a society. For example, they might show that a boy was
able to protect his family and community, and that a girl was
up to the task of having children. And, like the right haircut or
outfit today, tattoos were considered to make a person more
attractive.

The South Pacific

The islands of the South Pacific were about warm weather
and beachfront living. Native peoples showed lots of skin.
Today, the clothes we wear make statements about us.
Historically, tribal people used tattoos. To some extent, they
still do. Getting a tattoo was not a onetime thing that hap-
pened during an impulsive moment. Instead, a person's
tattoos were like a collection, with different designs added
over the years.

The Kayan, a tribe that lives on the island of Borneo,
started tattooing a girl when she turned ten. The process
lasted for three or four years, but had to be completed before

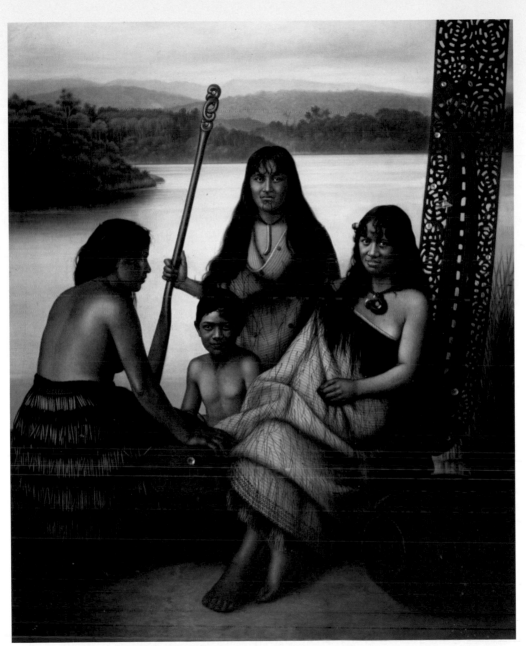

Artist Gottfried Lindauer painted many portraits of the New Zealand Maori tribe, helping preserve their tattoo tradition. Here, women in the picture are depicted with traditional, detailed tattoos around their mouths.

she gave birth to children. These tattoos often represented a woman's specific abilities—they were like permanent Girl Scout badges. Tattoos also had spiritual significance. People on Borneo thought that without a tattoo, a person would not pass into the spirit world after death. Also, without enough tattoos, they might not get the good seats once they got there.

Warriors from the islands of Tonga and Samoa attended ceremonies where they received a tattoo stretching from their lower backs down to their knees. Europeans sometimes called this the trouser tattoo. The designs were an elaborate series of bands and triangles, with some areas completely filled in.

On the Marshall Islands, tattoos reflected the ocean environment. Although the designs were abstract, they represented fish, bite marks, and shells. The organization was so detailed and exact that one observer said a fully tattooed man looked like he was "dressed in a suit of chains, resembling a medieval knight."

For centuries, the Maori tribe of New Zealand has practiced an elaborate form of face tattooing called moko. Symmetrical designs of lines and swirls cover the entire face. Historically, men were more heavily tattooed. Women opted to tattoo their lips and chins, which was considered attractive. The moko designs had specific elements, but each man's facial design was a little different. His tattoo reflected his status, family heritage, and specific skills. A Maori man knew his tattoo and could draw it to use as his signature.

Scarification

One practice related to tattooing is scarification. This process involves making deep cuts into the skin to make a design. When the cuts heal, the patterns are visible in the raised scar tissue. While the wounds are still open, ashes are rubbed into the cuts. This irritates the skin and makes the healing process take longer. Sometimes the cuts are reopened. Each time this happens, more scar tissue is formed. By the end of the process, the scars have created prominent ridges on the skin. They are often distinctly lighter in color than the skin around it, creating a contrast.

Scarification is particularly widespread in Africa. Although Africans do use tattoos, their dark skin makes them harder to see.

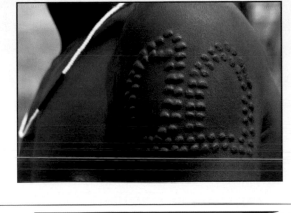

Skin is intentionally scarred to create designs that combine visual and textural elements.

In 1873, an artist named Gottfried Lindauer visited New Zealand. He painted more than one hundred pictures of Maori men with their tattoos. The collection is now in a museum. It is one of the best historical records of moko tattoo art.

The Americas

In South America, the Mayans and Aztecs lived in present-day Mexico and Guatemala. The Incans were farther to the south, in what are now Ecuador, Peru, and Chile. Today, crumbling ruins hint at these great civilizations. But the art that these ancient peoples carved into pottery or built into shrines still lives on in tattoos.

The Aztecs were the dominant culture from the 1300s to the 1500s. Art appreciation started early in the Aztec culture, and arts and crafts were a daily part of life. Their tattoos reflect this. The Aztecs liked designs that were colorful, detailed, and stylized. Tattoos were received as rites of passage and to show devotion to the gods. The sun god and the warrior god were two common choices. People also got tattoos that reflected the world around them. Animals such as large cats and birds of prey lived in the hostile jungles.

Tattoos served as a kind of identification system. Just as today your student ID card or driver's license says who you are, the color and design of an Aztec tattoo told which tribe a person belonged to.

Also, tattoos often proved a person's worth and status in the tribe. However, there was an exception to this during the Incan period, roughly 1500 BCE to 1500 CE. Members of the Incan royalty did not receive tattoos. Their reasoning? The sun god had already made them perfect. A tattoo would spoil that.

Some South American tribes still have an active tradition of tattooing. The Karaja tribe lives on an island in central Brazil.

Boys and girls here still receive tattoos when they reach puberty. A circle about the size of a penny is tattooed under each eye. Girls sometimes get a blue dot on their chin.

Farther north, in the current countries of the United States and Canada, Native American tribes also got tattoos. Men's tattoos proved their strength, and women's tattoos proclaimed their attractiveness. Today, people of Native American descent often get tattoos to celebrate their heritage.

A Dying Art?

Tribal tattooing is not nearly as widespread as it once was. In many cultures, the practice has been reduced or abandoned entirely. However, there are some efforts to bring back the old traditions. The old Western ideal—to squash traditional culture in favor of a Christian European viewpoint—has lost ground. Instead, there's a new appreciation of the diversity of cultures. As the practice of tattooing becomes more mainstream, the traditional styles are also making a comeback. In 2003, the television network PBS aired a program called *Skin Stories*. The director, Emiko Omori, said in an interview, "Tattoos are a real way of reclaiming a culture that was almost lost. In some cases in Hawaii, the connection is pretty thin and they are continually searching through the past. In New Zealand, there are lots of photographs documenting tattoo designs, but of course meanings are lost. It is always evolving."

Tribal people have also incorporated the imagery of other cultures into their designs. The Iban are a tribe that lives on

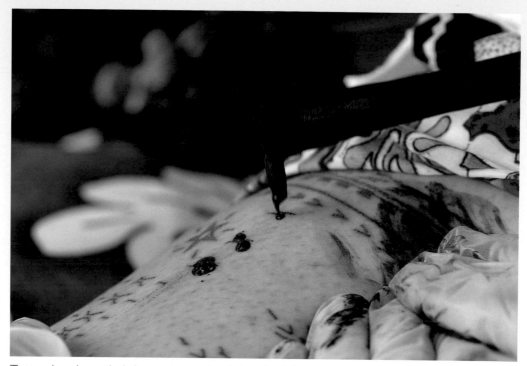

Tattooing is a thriving art on the island of Samoa, where people use tattoos to proclaim their heritage. Here, a young woman endures the pain of receiving a tattoo.

the coasts in Borneo. They have always adopted tattoos from neighboring tribes and even from outsiders. Traditional designs of dogs and stars are mixed with images that are decidedly modern, like airplanes and helicopters!

Samoan tattooists also incorporated symbols from other cultures. After World War II, for example, the American eagle started appearing in Samoan tattoos.

Some of the original reasons for tattooing are still reflected in today's tattoos. On Tahiti, for example, men like large designs using bold, thick black lines because the stronger lines are

associated with masculinity. Women on Tahiti, not needing to prove their masculinity, generally only get one smaller tattoo.

In 1990, a village on Savai'i, an island in Samoa, made having a tattoo a requirement for men. Today, not only do Samoans living in the islands get traditional tattoos, but so do Samoan immigrants living elsewhere. A tattoo is a way for people to proclaim their heritage and identity, even though they have left their native country. The *pe'a* (the traditional body tattoo of Samoa) is becoming popular even with people who are not Samoan. Just as with Captain Cook, tattoos are the ultimate souvenir for tourists. The tourist trade has helped revive traditional tattooing. At the same time, it has also cheapened it, taking away some of its special meaning. This has created a debate in the country: should non-Samoans get a tattoo that is not traditionally theirs?

Some history has been lost forever. The reasons behind the tattoos, or the circumstances under which they were given, will never be known. However, efforts are being made to revive what traditions do remain.

Asia and the Middle East

They might be the marks of traditional cultures, the brands of a criminal gang, or simply artistic statements. People in Asia get tattoos for any number of reasons—from religion to recreation. The attitudes toward them are just as varied. Some people like them, and others hate them.

China

As with many Asian countries, the traditions of tattooing in China are sometimes contradictory. Ethnic groups in China historically used tattoos to show social status. A tattoo would also indicate to which tribe a person belonged. Certain villages were vulnerable to enemy attacks. Sometimes the women would tattoo themselves to make themselves less attractive to the men from these tribes. If they were kidnapped, the tattoos helped identify them to rescue parties.

However, for centuries Chinese society frowned on tattooing. Tattoos were used to

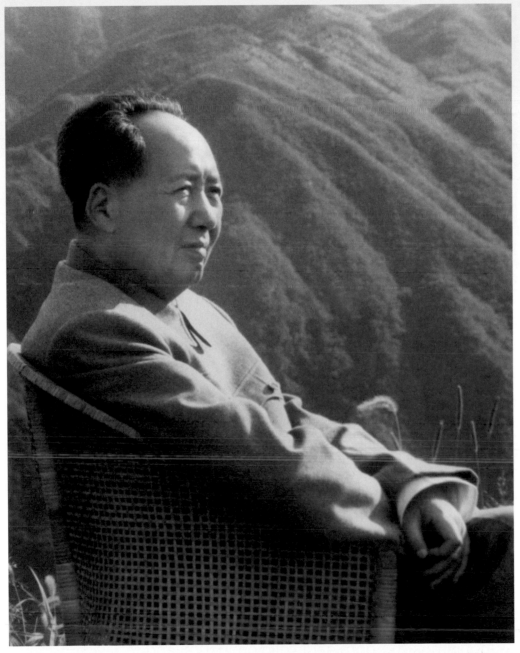

Chinese leader Mao Zedong outlawed tattoos during the "Cultural Revolution" of the 1960s, a movement created to squash liberal tendencies that were arising in the country.

punish outcasts and criminals. In the 1960s, China's leader Mao Zedong outlawed tattoos. Even today, they are not widely accepted. Members of the military are not permitted to have tattoos, and many private businesses refuse to hire people with tattoos.

Not surprisingly, traditional tattooing is dying out, although it still hangs on in certain tribes. The Drung people of south-west China tattoo girls at about age twelve or thirteen to show their maturity. Lines are drawn around the mouth, on the cheeks, and between the eyebrows to represent a butter-fly. The Dai people have similar customs. Women get tattoos on their hands, arms, and faces to enhance their beauty. Men want to advertise their bravery and strength, so they tattoo the body's muscular parts: back, chest, and biceps.

To show the Chinese government the importance of pre-serving these old customs, the China Association of Tattoo Artists recently helped some elderly women from the Dulong tribe leave their village for the first time ever to show off their tattoos at a convention.

Also, influences from Western cultures are creeping into China. As the country struggles for more individual rights, tat-toos slowly gain acceptance.

Thailand

Buddhism is the dominant religion in Thailand today, but this country has a long history of tribal cultures that started in its

dense forests. Tattoos often combine these histories. Tattooing is especially popular in rural areas and among the lower classes. However, the Thai government officially opposes tattooing. People who apply for government jobs must show their chests and arms to prove that they have no tattoos. To get around this, some people have their tattoos applied with invisible ink.

Thai people believe in the magical powers of tattoos. If they survive a brush with death, they often give credit to the protective power of their tattoos. The process of receiving a tattoo is accompanied by special rituals in order to activate its magical powers.

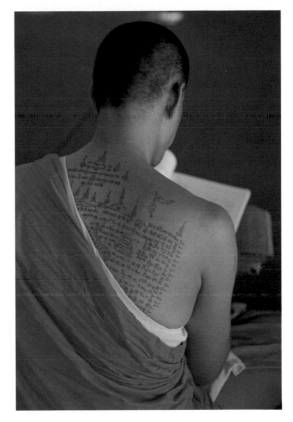

Buddhist tattoos, called Sak Yant, are often received during elaborate festivals and ceremonies.

Afterward, a person may have to observe certain behaviors in order to keep the tattoo working. The Thai also believe that too many tattoos can interfere with a person's personality and that some people simply don't have the mental strength to handle certain tattoos.

Sak Yant, or *yantra*, tattooing is a religious form of tattooing that is prevalent in Thailand, Laos, and Cambodia. It is also

spreading to parts of China. Sak Yant symbols represent Buddha's sacred teachings. Pictures of animals, gods, and divine words are part of Sak Yant tattoos. People get them to bring good fortune and luck.

Tattooing is a highly ceremonial process among Buddhist monks. The process is far removed from the sterile tattoo parlor in today's cities. Instead, the monks sometimes get hypnotized before they are tattooed with 6-foot-long (1.8-meter-long) swords that have been dipped in ink.

Burma, Vietnam, and India

The Shan ethnic group is a tribe originally from Burma (now Myanmar). To show their strength and maturity, Shan men received tattoos stretching from their waists to their knees. Animals and geometric patterns were etched with indigo ink by the tribe's medicine man. Today, Buddhist symbols are popular among the Shan tribe. Soldiers and police might choose a black tiger to protect them from death. A parrot is believed to bring good luck.

However, as in other Asian countries, the Burmese government officially opposes tattoos. At a recent concert, hip-hop star G-Tone pulled up his shirt onstage, showing a tattoo on his back. He was arrested. Also, pictures of tattooed people are not allowed to be printed in newspapers or magazines. The tattoos have to be "removed" with computer technology.

Traditional tattooing does survive in some isolated regions, such as the high mountains and dense forests of Vietnam and Burma. For example, the Chin Province in Burma is home to the Chinbok tribe. They are named for their tradition of women tattooing their chins. Each woman has her own individual design.

In India, people are strictly divided into social classes, or castes. Women's tattoos usually showed that they were inferior to men. Their tattoos were also believed to increase their fertility and make them attractive to men. Men of the upper castes usually got fewer tattoos than men in the lower castes.

The Japanese Tradition

Japan's neighbors, the Chinese, observed as early as 300 CE that Japanese men, "young and old," were tattooed all over. The Chinese, however, believed tattoos were undesirable. The Japanese eventually came around to this way of thinking. In the eighth century, a Japanese emperor was deciding on the fate of a traitor. Death was the accepted punishment. But perhaps the emperor was in a good mood because he decided to be merciful. Instead of death, the man was sentenced to tattooing.

This overall attitude persisted for another thousand years. Tattooing was illegal, reserved as a punishment for criminals and outcasts. Maybe that was better than death—or maybe not. It was not a "slap on the wrist" that was easily forgotten. Instead, people with tattoos were literally marked for life.

Despite Japan's artistic contribution to tattooing, the practice was shunned there for centuries. Today, tattoos are becoming more accepted and more popular, especially with youth.

Their families and friends no longer spoke to them, and they weren't able to join in community life.

A Japanese gang called the Yakuza thought tattoos were the perfect way to show their commitment. The pain of getting a tattoo proved their bravery. The permanence of a tattoo showed that they would be loyal forever. And since tattoos were illegal, it bound them together as outlaws. It was like a membership card that never got lost!

By the end of the seventeenth century, decorative tattooing was becoming more popular. Even though it was illegal, it was still a flourishing art. The full-body tattoo has its roots in Japan. Traditional Japanese tattoos—called *horimono*—were often single, large designs. They might be of famous heroes or have religious meanings. They covered a person's back, stretched up his arms and down his legs, and sometimes curled around to his chest. Besides the central figures, Japanese tattoos pay close attention to backgrounds, as well as to the colors and shading of the design.

Tattooing is now legal in Japan, but tattoos are still often seen as symbols of criminal activity. People with tattoos may be shunned in public places such as subways. The full-body tattoo has tanked in popularity. Even members of the Yakuza now opt for a simpler design on the arm.

Some younger people are starting to rediscover tattooing, but they are attracted more to Western-style designs than traditional Japanese ones. Tattoos are increasingly popular among women, however, because they are more likely to follow the fashion trends of Western cultures.

The Dragon Tattoo

If you're going to hang out with a dragon, it's probably best to do it in Asia. European dragons were brutal creatures with a nasty habit of destroying villages with their fiery breath. But in China and Japan, dragons were powerful—but good—creatures. They were intelligent, wise, and brave. Plus, they brought good luck and wealth. What's not to like? No wonder the image of a dragon is a common tattoo. Chinese dragons are varied: the celestial dragon takes care of heaven, while the earth dragon is in charge of Earth. The horned dragon is strong, while the hornless yellow dragon is celebrated for its knowledge. In Japan, a dragon's coloring indicates its personality and traits. Green dragons represent life and the earth. Black dragons have the advantage of experienced, wise parents. As tattoos, dragons offer a wide array of meanings and a host of artistic possibilities.

The Middle East

Two cultures in the Middle East have had a huge influence on tattooing. The Bedouin are an Arab people (their name means "people who live in the desert"). The Nawar were Gypsies in the region. The Nawar usually tattooed the Bedouin, as well as themselves. This tradition is not as widespread as it once was, but it still exists in places. However, the designs used by Gypsies and Bedouin are different. Although the two cultures share a tradition of tattooing, they remain separate by using distinct tattoo designs.

In the Middle East, the traditions of tattooing battle more conservative influences. However, some Middle Eastern women still get tattoos, which are thought to make them attractive to men.

Tattoos were a way for women to attract men. They often tattooed their chins with an extensive pattern of blue stars. Some women still may get tattoos between their eyebrows, often a triangle of crossed lines.

Islam is the main religion in the Middle East. (Its followers are called Muslims.) Tattooing is prohibited under Islamic law, and many Middle Eastern governments forbid the practice. However, tattooing has been around longer than Islam in the Middle East. Tribes from Egypt, North Africa, and Asia all helped develop a tattooing tradition in the Middle East, and it was a common practice for centuries. It may be coming back. Western influences are creeping in, battling the establishment. Although tattooing is extremely uncommon in Iran, for example, women there are starting to get tattoos that they can display in private, even if they still hide them in public.

Europe and the United States

ver thousands of years, tattoo art evolved on the islands of Polynesia, the jungles of South America, and the plains of North America. When Europeans came into contact with these cultures, tattoos changed. Over the next two hundred years, the free-thinking, progressive attitudes of Western people had a huge influence on tattoo art. People from Europe and the United States introduced new designs and styles of art. They also introduced new reasons for getting tattoos.

The Western Tradition

When Captain Cook and his crew returned to England, they started a new tend. Tattoos had been fashion no-no's. But sailors liked them, and they started to make a comeback. Rather than copy tribal tattoos, sailors chose symbols that represented the details of their own lives. Tattoos could be both good luck charms (they

were hard to lose), as well as symbols that the sailor was part of a fraternity. Anchors were popular, since they represented stability, which was not always possible on a stormy sea. A pig on one foot and a rooster on the other was believed to protect a sailor from drowning, since neither of those animals could swim.

Western designs used identifiable pictures, as opposed to the abstract patterns that tribal cultures favored. Also, unlike the detailed, full-body tattoos of the Japanese, Western tattoos were smaller and simpler. Instead of having one large tattoo, a person was more likely to have a collection of smaller ones. This came out of the sailor tradition. A sailor might get one tattoo in Singapore and another in Hong Kong. They became mementos of where he had been. One tattoo didn't tell the whole story—as it might in a full-body Japanese tattoo. Instead, it was a picture or symbol that represented the story.

Tattooing spread to other branches of the military as well. In the United States, especially during wartime, service-men might prove their loyalty with patriotic images such as flags, eagles, and "Uncle Sam"—a crusty old guy represent-ing the government. "Americana"—symbols and designs representing things that were uniquely American—were also popular. It might be a Coca-Cola bottle or a cartoon character like Mickey Mouse. In the 1960s, biker culture exploded. Motorcyclists traveled in packs and projected a tough image. They flocked to Harley-Davidson motorcycles, and the com-pany's logo started showing up on the arms of motorcycle

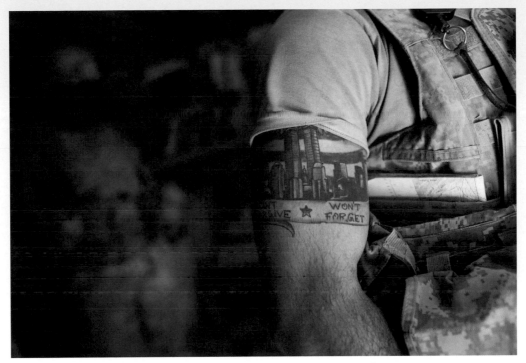

A man wears a tattoo of New York City's World Trade Center to commemorate 9/11. Tattoos with patriotic images or Americana symbols have always been popular in wartime.

enthusiasts. Later, other fringe groups—like hippies and punks—took up tattooing.

For much of the twentieth century, tattoo art in the United States was straightforward and relatively simple. However, by the 1970s, this "old school" style was evolving. Artists began to adopt the rich colors and lavish details of Japanese tattooing, as well as the fantastical images. In the United States, the size and detail of a Japanese tattoo was mixed with American imagery. More than anything, the Western tradition was a soup of ideas, borrowing from all the world's cultures

and then combining them with the bigness and brashness of Western thought.

Runes and Knots

Tattoo art in most of Western Europe mirrors what is seen in the United States. However, some styles draw on Europe's older cultures. The Vikings were a seafaring people who dominated Scandinavia, in Northern Europe, more than a thousand years ago. The Celts are even older. They thrived in Britain, Scotland, Ireland, and other parts of Europe from about 500 BCE to 400 CE. People who can trace their ancestry to these peoples are especially attracted to tattoos that reflect these cultures.

Vikings used a form of writing using symbols called runes. Runes are pictorial symbols that tell a story. They also had power of their own. They could be used to see the future, or cast a spell. As tattoos, runic designs are both intricate and simple. For the wearer, they combine visual artistry with deeper power. A *vegvisir* is a kind of compass that provides direction for the wearer. The *fylfot* is in the shape of a swastika. During World War II (1939–1945), the German Nazi government used the swastika sign, and it became associated with tyranny and evil. However, for centuries before, the swastika was a good luck symbol.

Probably the most well-known Celtic design theme is a knot. Lines can be braided together in an intricate pattern or merely crossed once or twice in the ultimate simplicity.

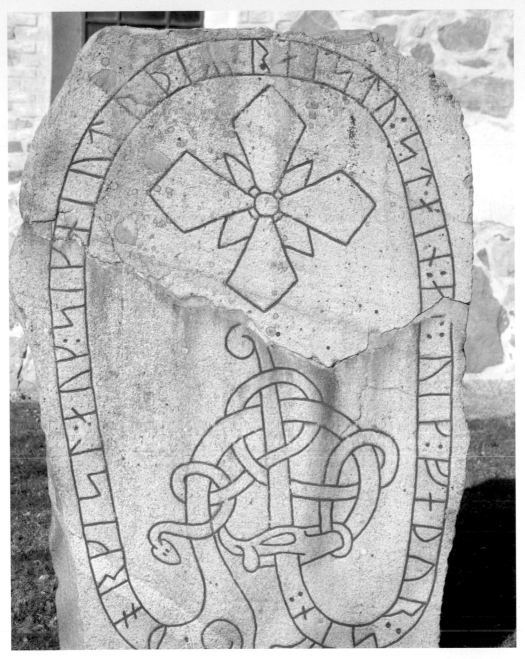

A Viking runestone erected outside a church shows the intricate patterns of a runic design. Considered both beautiful and powerful, runes are often translated into tattoos.

Knot tattoos are often encased in circles. These mazelike designs symbolize the connections in life. Crosses and triskelions—a pattern resembling a three-pronged swirl—are other Celtic designs frequently translated into tattoos. Although the imagery of Celtic designs can be similar to tribal tattoos, it actually was adopted from other forms of art.

Religious Tattoos

As Christianity spread throughout Europe, the popularity of tattooing began to fade. Christians believed tattoos were the marks of pagans and heathens, people who did not honor the "true" God. They pointed to a verse in the Bible that said God prohibited tattooing. Interestingly, tattoos also became a way to show religious devotion. Despite the biblical warning against it, Christian pilgrims—people who took a long journey to a holy place—often got a tattoo as proof of their visits.

Today, religious tattoos are a growing category. Some Christians show their faith by inking tattoos of crosses, pictures of Jesus, Bible verses, or even more elaborate scenes. A growing number of younger Christians gravitate to the basic ideas of Christianity, but still want the freedom to express themselves. They might use the tattoos to inspire them or reinforce their faith.

Jews are more resistant to the idea. During World War II, Jewish prisoners were tattooed by German Nazis to identify them. Not only was this cruel, but it also violated a Jewish law

A Cross to Wear

Historically, the Eastern European countries of Bosnia, Albania, and Croatia—collectively known as the Balkans—have formed a fence. On one side was Western Europe, which was mostly Christian. On the other were the countries that practiced Islam. When the Turks invaded the Balkans in the fifteenth century, they brought Islam with them. Many Balkans became Muslim. However, some stayed Christian. These Christians often received a tattoo to signify their religion. For girls, this was usually a cross on their hands, arms, or shoulders. Boys were less likely to get tattooed, although they might receive a small cross on their fingers. Christians might have gotten these tattoos voluntarily. It's also possible the Turks forced them to do it to "mark" them. Either way, the tradition continued well into the twentieth century, with teenage girls gathering at church on Catholic holidays to receive a tattoo and mark this rite of passage.

not to have the body tattooed. Today, however, the practice is gaining some acceptance among Jews, especially younger ones. The horrors of World War II are not as fresh, and the influence of Western popular culture is everywhere. Even traditionally Jewish nations such as Israel are seeing an upswing.

In some parts of the world, Muslims also struggle with the question of whether to get tattoos. Officially, the religion forbids it, but some Muslims reject this point of view and get them anyway.

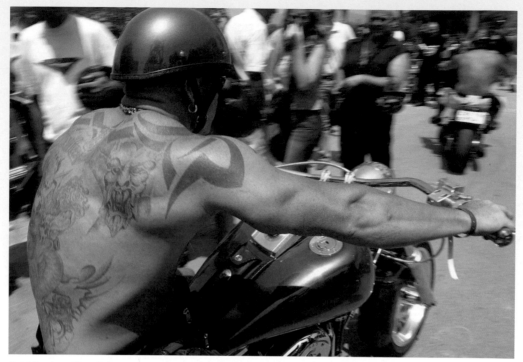

At Harley-Davidson motorcycle rallies, heavily tattooed bikers are a common sight. Many bikers choose to wear the logo for the Harley-Davidson company in addition to more personal tattoos.

Express Yourself

In Europe and the United States, tattoos became the marks of a new class of outcasts, associated with men who were rough and crude. Sailors were far too coarse to be accepted into polite society. Punks, hippies, and bikers belonged to their own groups and were happy to stay there. Like the slaves of ancient Rome, or the criminals of ancient Japan, they were outsiders. But in these cases, they were proud of it.

Today, the motives behind getting a tattoo sometimes seem contradictory. On the one hand, they might be a way to associate oneself with a particular group. On the other hand, they might be a way to express individuality. The desire to be "different" can even put the person back into a group—people who want to be different!

Why a person gets tattooed, what design he or she chooses, where on the body he or she gets tattooed—all of these factor into the decision to get a tattoo. It might be a fashion statement or a way to remember a loved one or a special time. It might be a symbol of individuality or identity, or an image that proclaims a person's commitment to a group, religion, or philosophy.

While many tribal and Eastern cultures recognized the beauty of tattoos, few of them celebrated tattoos as a way to advertise a person's individuality. Western cultures added that significance to the process of tattooing.

A Developing Art

Like the intertwined cords of a Celtic knot tattoo, tattoo art and designs have evolved along with the practice itself. Part of it has to do with the popular culture of the time. Part of it has to do with the artist's abilities and influences. And part of it has to do with the wishes of the person getting tattooed.

Tattoo Trends

Like any other type of art, tattooing has developed in different styles. "Traditional," or "old-school," tattooing ruled in the late 1800s and early 1900s. Pictures of anything from butterflies to Betty Boop come under the "traditional" category. These designs are simple and strong, but not necessarily realistic. "New-school" designs might be modern, exotic, or fantastical. They use a broader array of colors and more blending and shading.

"Black and gray" or "jailhouse" is a style that started in prisons. Tattoo artists used homemade equipment, and they did not have

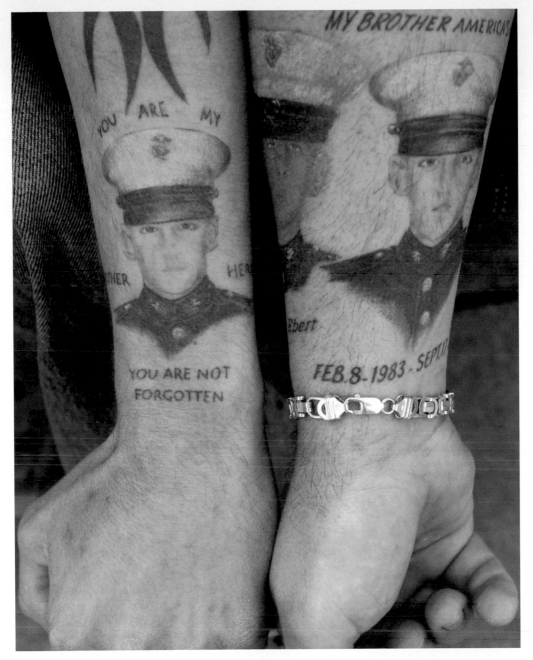

Realistic tattooing styles can be used to create images that resemble portraits or photographs. Here, a man wears tattoos that honor a soldier who was killed in war.

any colored ink. Instead, they used a makeshift dye made from cigarette ashes. Without color, black-and-gray tattoos depend on the artist's ability to use line and shading.

"Fine-line" tattooing opened the door to even more designs. These tattoos are detailed, realistic paintings. Instead of a general image of a person, a fine-line tattoo can produce a picture of an actual person—like a snapshot on your skin. Because these designs are so intensely detailed, tattooists have to be careful. Unlike the canvas of a painting, the skin gets saggy and wrinkly over time—and so will whatever's on it. Fine-line tattoos are especially vulnerable.

Chicano tattooing began in the Southwest, among Latin gangs, about the middle of the twentieth century. Chicano tattoos were done in a black-and-white, fine-line style that was ideal for portraits and often used Catholic imagery, such as pictures of Jesus. Today, Chicano tattoos may use color as well. This style of tattooing made possible some of the highly detailed designs we see today.

Biomechanical tattooing started in the late 1970s and early 1980s. These tattoos look a little bit like funky X-rays. The tattoo seems to strip away the skin, revealing the layers underneath. However, instead of just bones and blood vessels, these tattoos show a combination of gears and wires, as well as the living parts of the body.

All of these styles are still in use today. However, as the demand for tattoos grows, so does the demand for more, and different, designs. Customers used to walk into a tattoo parlor and choose from the "flash" on the wall. Flash was a

collection of pictures showing possible tattoos. Many were mass-produced images that were available many places. Today, clients often request a custom design, which may combine different styles and will be unique to the wearer.

Calligraphy and Lettering

A picture might be worth a thousand words, but sometimes a word is all you need. In addition to patterns and pictures, a popular tattoo choice today is with lettering. A simple proclamation of "family" or "pride" clearly states the wearer's priorities. Initials are another approach. These might be of a person's name or the first letters of the words in a motto. For example, the letters "LYD"—for "Live Your Dreams"—might be artistically intertwined to make a pleasing symbol as well as a statement.

Old English, Gothic-style lettering has a strong, imposing look and is often chosen by gang members or other people wanting to project a tough image. This style of lettering was—and still is—used in prisons and has come to be associated with criminal activity. However, its bold lines also make it a good choice when combined with other tattoo styles, such as Celtic or tribal designs.

Another distinctive lettering style comes from graffiti art. The fat and funky letters of this street art evoke the creativity and playfulness of hip-hop. The curves of Arabic or Sanskrit (an ancient language from India) can mimic the curves of the body.

Bold, elaborate lettering in various styles makes a simple, powerful statement. Names, initials, or individual words provide a glimpse of the wearer's identity or beliefs.

Also on the rise is Asian lettering. Many Asian languages do not use an alphabet that combines letters or sounds into words. Instead, these languages use characters that represent an object or even an entire idea. Asian symbols representing "peace," "love," or "harmony" are especially popular in the West.

Tattoo artists who specialize in calligraphy will also work with clients to design their own lettering styles. These can express their own personal style and can be customized to work with other tattoos.

Kanji

The ancient cultures of China and Japan have twined around each other like a dragon's tail. Kanji is a type of Japanese writing that actually came from the Chinese. A kanji character uses several small lines that combine to suggest different actions or objects. These lines are drawn within the imaginary boundary of a square. The effect of three or four symbols in a row is complex, yet controlled. Ancient scribes painted strokes that were admired for their beauty. Today's tattoo artists often work to duplicate the delicate details of ancient kanji characters. However, reading kanji takes practice. The same symbol can have different meanings depending on the context. People who get kanji tattoos should be certain of what the symbol says.

New Tribalism

Traditional tribal tattoos are also gaining new ground, not only among the tribes that originated them, but also among people in all cultures. "New tribalism" got its start around 1990 and surged in popularity over the next decade. While no longer considered cutting-edge, this style still appeals to many.

Leo Zulueta is a tattooist who is often credited with starting new tribalism. He said, "I think the kind of people that are drawn to [new tribalism] are looking for something deeper than the high-tech society that we live in."

Part of the return to tribalism, sometimes called "modern primitive," has to do with the designs. They are simple yet striking. A deeper reason lies with the experience itself. By turning to an ancient ritual such as tattooing, people feel that they can reconnect with history. They are channeling an activity that gives them access to a community that would otherwise be lost. According to tattoo artist Lyle Tuttle, for some people, getting a tattoo is "a form of finding their lost tribal ancestry." In some cases, these ancient cultures have been stamped out, but tattoos can provide a link to what once existed.

Of course, the tattoo designs may not be exactly the same as they were centuries ago. For example, in the 1960s, American Peace Corps volunteers on Samoa sometimes got an armband tattoo before they left. Anthropologists aren't sure who had this idea first. Was the armband a traditional Samoan tattoo? Or did the volunteers introduce it? Either way, those visitors to the islands brought back tattoos that represented a life that was both simple and exotic.

Fusion of Cultures

The act of tattooing has gone mainstream. It's a stream that is powered by artistic currents from cultures all over the world. They have blended and mixed with each other. People are combining elements from different societies. It wouldn't be strange to see a man from Germany with an Aztec sun god, a Polynesian man with a race car, or an American soccer mom with a Celtic cross.

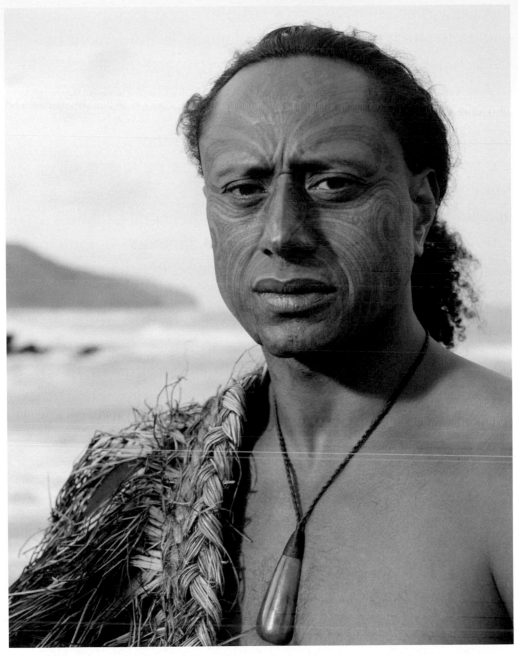

The traditional moko facial tattoos of New Zealand's Maori tribe may be incorporated with contemporary images, as tattoo styles from around the world begin to blend together.

Design styles have also started to blend together. The elaborate chest markings of the Marshall Islands might be used in conjunction with the distinctive moko facial tattooing of New Zealand's Maori. Japanese styles have had a tremendous effect. "The whole world of traditional Japanese art and tattooing is very influential in today's modern tattooing to the point where almost every tattoo reflects a lesson taken from Japanese art," Seattle tattoo artist Damon Conklin said in a *Smithsonian* magazine article. The full-body Japanese tattoo might tell the story of traditional Japanese heroes, or it could show Batman and the Joker battling it out on the streets of Gotham.

East and West have traded back and forth so much that they've nearly reversed themselves. In the United States, people love Eastern symbolism, such as Asian characters that represent spiritual enlightenment. In Asia, youths tend to choose flashy, specific images from Western culture.

Over the centuries, tattoos have served many functions. They've been a way to heal the body, prove religious devotion, and show someone's status in society. But now, perhaps no other art form is so intensely individual. Tattoo art is as varied as the artists who design it and the people who get it.

Add them up, and the world's people probably have billions of tattoos. But no two are quite the same. They are not simply pictures, but choices. Tattoos are an art form that reaches millions but remains the most personal of them all.

GLOSSARY

abstract Not specific; using symbols or designs to represent objects or ideas.

ancestry A person's cultural background or heritage.

calligraphy Lettering that is produced with attention to beauty and form.

fantastical Not real; existing only in a made-up environment.

flash Pictures of available tattoo art and designs.

flourish To grow and thrive.

horimono Traditional Japanese tattoos.

imagery Pictures or visual symbols that represent a certain idea.

moko The traditional facial tattooing of the Maori tribe.

pe'a The traditional body tattoo of Samoans.

pigment A coloring or dye.

rite of passage An event that represents a milestone in a person's growth or development.

sacrilege Speaking or acting against God.

Sak Yant A type of Buddhist tattoo (also yantra).

scarification The process of scarring the skin to create designs.

status A person's importance or position in society.

stigma Something that creates a negative impression.

superstition A belief in something, often considered unfounded.

symbolism Ideas that are represented or implied by images or objects.

symmetrical The same on both sides; a mirror image.

FOR MORE INFORMATION

American Museum of Natural History

Central Park West at 79th Street

New York, NY 10024-5192

(212) 769-5100

Web site: http://www.amnh.org
The museum features exhibits on all aspects of natural history and has mounted major exhibits on tattooing, which can be viewed online.

Alliance of Professional Tattooists

215 West 18th Street, Suite 210

Kansas City, MO 64108

(816) 979-1300

Web site: http://www.safe-tattoos.com
The alliance, founded in 1992, promotes health and safety issues related to tattooing.

National Tattoo Association

485 Business Park Lane

Allentown, PA 18109

Web site: http://www.nationaltattooassociation.com
Founded in 1976, the association strives to promote the idea of tattooing as art to the general public, as well as ensure safety and quality within the industry.

Paul Rogers Tattoo Research Center

c/o Tattoo Archive

618 West 4th Street

Winston-Salem, NC 27101

(336) 722-4422

Web site: http://www.tattooarchive.com/research_center.htm
Operated through the Tattoo Archive store, the center works with tattoo artists and enthusiasts to preserve and document tattoo history.

Triangle Tattoo and Museum

356B North Main Street
Fort Bragg, CA 95437
(707) 964-8814
Web site: http://www.triangletattoo.com
Founded in 1986, the museum displays tattoo artifacts from around the world and curates exhibits on different styles and trends in tattoo art.

Worldwide Tattoo Canada

Unit C–7167 Gilley Avenue
Burnaby, BC V5J 4W9
Canada
(604) 438-9700
Web site: http://www.worldwidetattoo.ca/english
Worldwide Tattoo is an international supplier of tattooing materials.

Web Sites

Due to the changing nature of Internet links, Rosen Publishing has developed an online list of Web sites related to the subject of this book. This site is updated regularly. Please use this link to access the list:

http://www.rosenlinks.com/ttt/taaw

FOR FURTHER READING

Arbuthnott, Gill. *The Keepers' Tattoo*. New York, NY: The Chicken House, 2010.

Barnes, Jennifer. *Tattoo*. New York, NY: Delacorte, 2007.

Currie-McGhee, L.K. *Tattoos and Body Piercing*. Farmington Hills, MI: Lucent, 2006.

Dunford, Betty, and Reilly Ridgell. *Pacific Neighbors: The Islands of Micronesia, Melanesia, and Polynesia*. Honolulu, HI: Bess Press, 2006.

Feinstein, Stephen. *Captain Cook: Great Explorer of the Pacific* (Great Explorers of the World). Berkeley Heights, NJ: Enslow, 2010.

Golden, Christopher. *Poison Ink*. New York, NY: Delacorte, 2008.

Green, Terisa. *Ink: The Not-Just-Skin-Deep Guide to Getting a Tattoo*. New York, NY: New American Library, 2005.

Hardy, Lal. *The Mammoth Book of Tattoos*. Philadelphia, PA: Running Press, 2009.

International Tattoo Art. Current issues.

Levin, Judith. *Tattoos and Indigenous Peoples*. New York, NY: Rosen Publishing, 2008.

Levy, Janey. *Tattoos in Modern Society*. New York, NY: Rosen Publishing, 2008.

Marr, Melissa. *Ink Exchange*. New York, NY: HarperCollins, 2008.

Nagle, Jeanne. *Tattoo Artists*. New York, NY: Rosen Publishing, 2008.

Porterfield, Jason. *Tattoos and Secret Societies*. New York, NY: Rosen Publishing, 2008.

Rattigan, Anita, and Betsy Badwater. *Temporary Tattoos for Girls*. Secaucus, NJ: Chartwell Books, 2010.

Roleff, Tamara. *Body Piercing and Tattoos*. Farmington Hills, MI: Greenhaven Press, 2008.

Swallow, Jerry. *Traditional American Tattoo Design: Where It Came from and Its Evolution*. Atglen, PA: Schiffer Publishing, 2008.

Tattoo You!: Tons and Tons of Temporary Tattoos. Kennebunkport, ME: Applesauce Press, 2011.

Thorne, Russ, and Andrew Trull. *Temporary Tattoos for Guys*. Secaucus, NJ: Chartwell Books, 2010.

BIBLIOGRAPHY

Asian Tattoo Online. "Asia Tattoo History and Modern Fact." June 2, 2010. Retrieved August 16, 2010 (http://www.asiantattooonline.com/2010/06/02/tattoo-history-and-modern-actual-fact-in-asia).

Bjorkell, Stina. "Skin Deep: The Art of Tattooing in China." Radio86.co.uk, November 28, 2007. Retrieved August 22, 2010 (http://www.radio86.co.uk/explore-learn/lifestyle-in-china/4562/skin-deep-the-art-of-tattooing-in-china).

Corney, John. "The Picts, the Tattooed Aboriginal Tribes of Scotland." *Ariki Art*. Retrieved August 8, 2010 (http://www.arikiart.com/tattoo-body-art/tribal-tattoos.htm).

DeMello, Margo. *Bodies of Inscription: A Cultural History of the Modern Tattoo Community*. Durham, NC: Duke University Press, 2000.

Finan, Eileen. "Is Art Just Skin Seep?" *Time*, April 22, 2002. Retrieved August 14, 2010 (http://www.time.com/time/magazine/article/0,9171,901020429-232672,00.html).

Gilbert, Steve. *Tattoo History: A Source Book*. New York, NY: Juno Books, 2000.

Helfrich, Benjamin. "The Needle for the Nail: Christians Showing Faith, Independence Through Tattoo." News21. Retrieved August 8, 2010 (http://newsinitiative.org/story/2007/08/16/christian_tattoo_the_needle_for).

Ho, Gary, Jeremy Hogan, Meghan Hoke, Nathan Holmes, Mariko Ikemori, Michael Jordan, and Joy Joby. "History of

Tattoos Around the World." Retrieved August 16, 2010 (http://www.spaceports.com/~meggie/psu/art002/tattoos).

Krcmarik, Katherine L. "Tattooing Around the World." Retrieved August 16, 2010 (https://www.msu.edu/~krcmari1/individual/world.html).

Lineberry, Cate. "Tattoos: The Ancient and Mysterious History." Smithsonian.com, January 1, 2007. Retrieved August 14, 2010 (http://www.smithsonianmag.com/history-archaeology/tattoo.html)

National Geographic. "Tattoos." Retrieved August 8, 2010 (http://www.nationalgeographic.com/tattoos).

Ong, Tan. "Buddhist Tattoos: A New Trend in Singapore." *The Chakra*, February 17, 2010. Retrieved August 22, 2010 (http://www.chakranews.com/buddhist-tattoos-a-new-trend-in-singapore/261).

Paquette, David. "Tattoo not Taboo." *The Irrawaddy*, February 2008. Retrieved August 16, 2010 (http://www.irrawaddy.org/article.php?art_id=10096&page=1).

Rio, Dale, and Eva Banchini. *Tattoo*. Philadelphia, PA: Running Press Book Publishers, 2004.

Thomas, Nicholas, Anna Cole, and Bronwen Douglas, eds. *Tattoo: Bodies, Art, and Exchange in the Pacific and the West*. Durham, NC: Duke University Press, 2005.

Van Dinter, Maarten Hesselt. *The World of Tattoo: An Illustrated History*. Amsterdam, The Netherlands: KIT Publishers, 2005.

Young, M. *Agony and Alchemy*. Prescott, AZ: Hohm Press, 2005.

INDEX

About the Author

Diane Bailey has written more than a dozen books for children and young adults on subjects ranging from sports to states to celebrities. While researching and writing this book, she was fascinated with how the traditional art form of tattooing has become the ultimate in contemporary culture. Bailey lives in Kansas with her two teenage sons.

Photo Credits

Cover (top) Michael Goldman/Taxi/Getty Images; cover (bottom) Roslan Rahman/AFP/Getty Images; p. 5 Photos.com/Thinkstock; p. 9 South Tyrol Museum of Archaeology, Bolzano, Italy/Wolfgang Neeb/The Bridgeman Art Library; pp. 11, 14 Hulton Archive/Getty Images; p. 17 Alison Wright/National Geographic Image Collection/Getty Images; p. 19 The Bridgeman Art Library/Getty Images; p. 21 Win Initiative/The Image Bank/Getty Images; p. 24 Dean Purcell/Getty Images; p. 27 RDA/Hulton Archive/Getty Images; p. 29 Stephen Studd/Photographer's Choice/Getty Images; p. 32 Access E/WireImage/Getty Images; p. 35 Frank & Helen Schreider/National Geographic Image Collection/Getty Images; p. 39 Spencer Platt/Getty Images; p. 41 Anna Yu/Photodisc/Getty Images; p. 44 Lluis Gene/AFP/Getty Images; p. 47 Chip Somodevilla/Getty Images; p. 50 Medioimages/Photodisc/Getty Images; p. 53 Mike Powell/Stone/Getty Images.

Designer: Les Kanturek; Editor: Bethany Bryan;
Photo Researcher: Karen Huang